AYLESBURY

HISTORY TOUR

First published 2023

Amberley Publishing
The Hill, Stroud,
Gloucestershire, GL5 4EP
www.amberley-books.com

Copyright © Charles Close, 2023
Map contains Ordnance Survey data
© Crown copyright and database
right [2023]

The right of Charles Close to be
identified as the Author of this work
has been asserted in accordance with
the Copyrights, Designs and Patents
Act 1988.

British Library Cataloguing in
Publication Data.
A catalogue record for this book is
available from the British Library.

ISBN 978 1 3981 0295 8 (print)
ISBN 978 1 3981 0296 5 (ebook)

Origination by Amberley Publishing.
Printed in Great Britain.

INTRODUCTION

Aylesbury is the town on the hill that became a county town in an area that was once part of the Cretaceous Sea. Frederick Griggs noted, in his *Highways & Byways of Buckinghamshire* (1910), that Aylesbury was primarily a focus for the vale's agriculture. He noted no particular industry, explaining that: 'The social aspect of agriculture may be summed up in the fact that the wages of labourers were never more than one shilling [5p] a day in the eighteenth century, while they were three or four times that amount today [1910].'

Griggs offers the curious information that all the inns of England were originally under the control of the monasteries. There were sixty public houses in 1900, and thirty-one grocer's shops. The King's Head, hidden away at the top of the sloping Market Square, is a worthy remnant of that bygone world. It is believed that it was built to honour King Henry VI's wife Margaret.

The Roman's passed this way, building Akerman Street, now the A41 and no longer cutting down the High Street. There are inner and outer ring roads, such has been the growth. Two more major roads developed connecting Aylesbury with Oxford, Bletchley and a second route to London, via a gap in the Chilterns at Wendover. Road numbering commenced after the First World War.

A branch of the Grand Union Canal opened in 1814, halving the price of coal for the gasworks. The first railway station was built in 1839 in what is still Railway Street, connecting to Stephenson's West Coast Main Line (LNWR), running out via Stocklake to Cheddington.

The town's current railway station was built in 1863 when the Great Western branch connected with Princess Risborough. The line was extended to Verney Junction, along with a new Metropolitan and Great Central line into Marylebone and Baker Street in the 1890s.

The town played its part in two world wars, the newly formed RAF opening a training camp at nearby Halton. Grand houses were turned over to the military and munitions. The First World War stimulated motor vehicles, road haulage and bus companies.

The drab, conforming 1950s gave way to rebellion and pop music, with the Rolling Stones performing at the Granada in 1965. A football team rose and disappeared, and there was a post-war boom in housebuilding, which started with Southcourt. Industry diversified, with newcomers out of London and the overspill. Change has been unabated, with so much of the old disappearing when Friar's Square and the new county offices arrived. The quaint, old Bucks County Police Station has been replaced by a fortress in the old Walton village, its heavy gates exiting near the pond.

The Thatcher years brought more change. Agriculture declined, so a multiplex cinema and restaurants replaced the cattle market. The pandemic in 2020 brought fresh uncertainty to a town that now has its own university college and high hopes for a future under a new unitary Buckinghamshire Council. The population has trebled since the 1960s, and is now over 60,000.

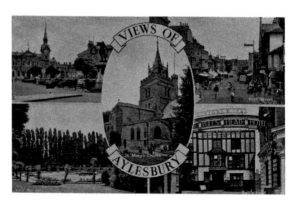

Images of Aylesbury, *c.* 1955. St Mary's Church is in the centre, while clockwise are Market Square, High Street, Vale Park and the false-timbered Bulls Head, which was demolished in 1969 and is now the Market Square entrance to Hale Leys Shopping Centre.

KEY

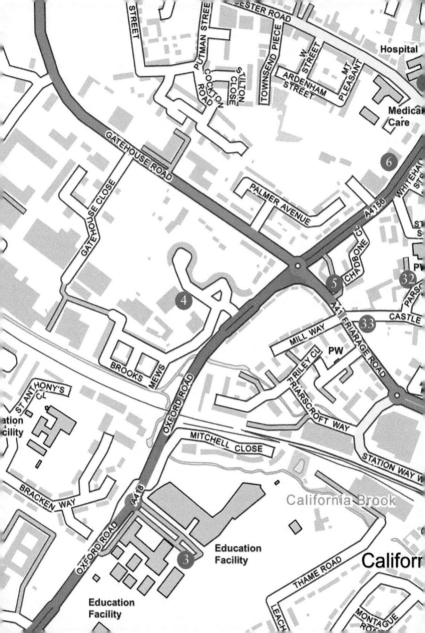

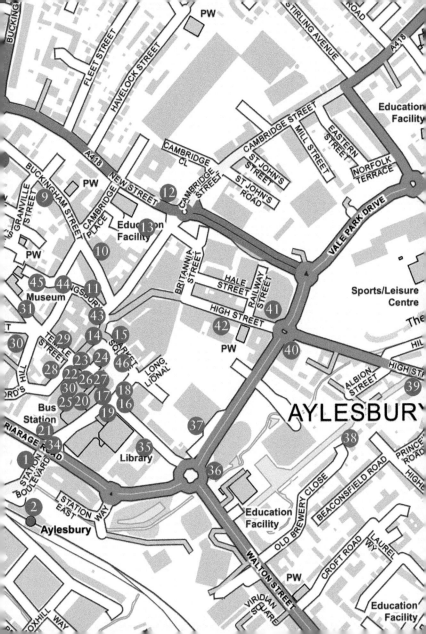

1. BUCKS HERALD PRINTWORKS

Bucks Herald Printworks, conveniently close to the railway station yard in the 1950s. Old-fashioned hot metal and typesetting was replaced by digital printing in the early 1980s. The building was demolished in 1966 to make way for the multistorey approach road along Station Way.

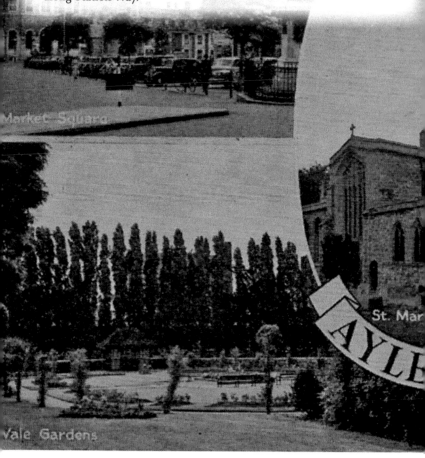

Market Square

St. Mar

AYLE

Vale Gardens

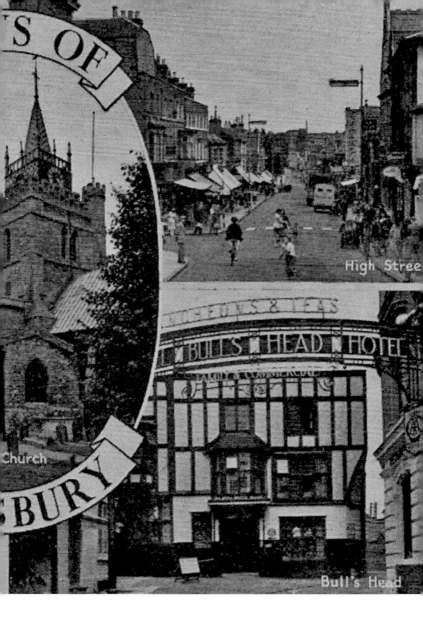

S OF

BURY

Church

High Stree

BULL'S HEAD HOTEL

Bull's Head

2. RAILWAY THROUGH AYLESBURY

Acts of Parliament established an east and west coast railway line. Inevitably somebody was going to promote a line up the centre, hence the Great Central Line coming through Aylesbury, en route to the Midlands. Here we see a northbound steam loco, with train en route to the Midlands, taking on water while the West Indian guard deals with freight. Immigrants were vital to Britain's post-war nationalised rail system.

The Metropolitan Railway Company, later incorporated into the London Underground, shared this route as far as Calvert Junction, then on to Verney Junction. The last through steam train ran to Nottingham on 3 September 1966. Steam trains were eye-catching in those last days, as we can see from the little family who have stopped to watch from the footbridge. Crossing the bridge takes us toward Southcourt, the first major post-war housing development. The path also offers the choice of following alongside California Brook, on past Aylesbury College and on to the Oxford Road.

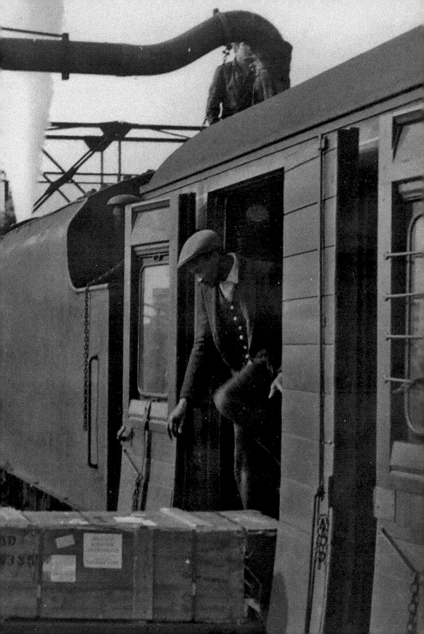

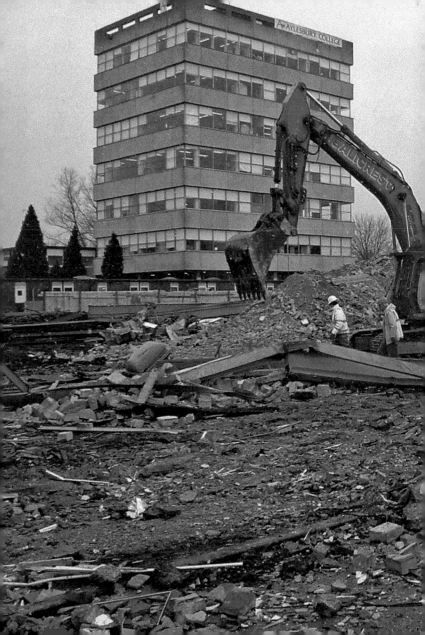

OXFORD ROAD
3. AYLESBURY COLLEGE OF FURTHER EDUCATION

Aylesbury College of Further Education's demolition in 2005. The college was opened by Princess Alexandra in 1964. It cost £315,000. The modern campus is very different, as is the world of education.

4. OLD TERRITORIAL ARMY DRILL HALL

Walking past the college, a modern paved walkway takes us up on to the Oxford Road. Turning right back into town, there is a gleaming new Territorial Army Drill Hall. Here we see the old hall just before demolition in 2001.

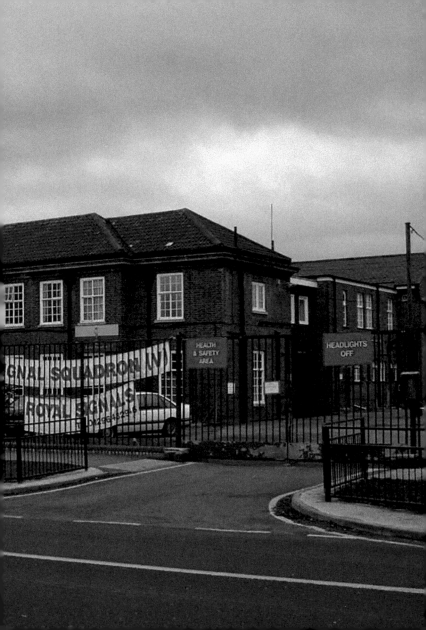

5. HEN & CHICKENS

Following Oxford Road to the roundabout, on the corner, where Friarage Road bears right, there is a modern low-rise block of red-brick flats. They replaced Big Hand Moe's, previously the Hen & Chickens pub. The original Hen & Chickens is shown here in the 1950s. A new pub of the same name was built to replace it in the 1960s. (D. J. Huntley)

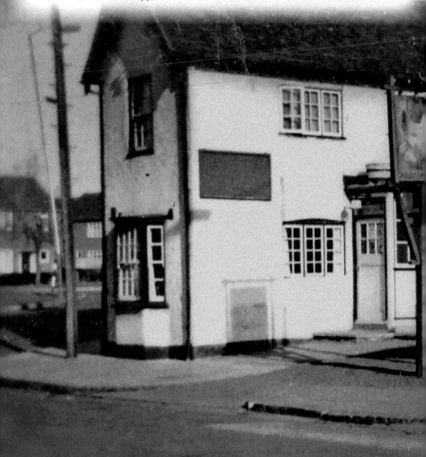

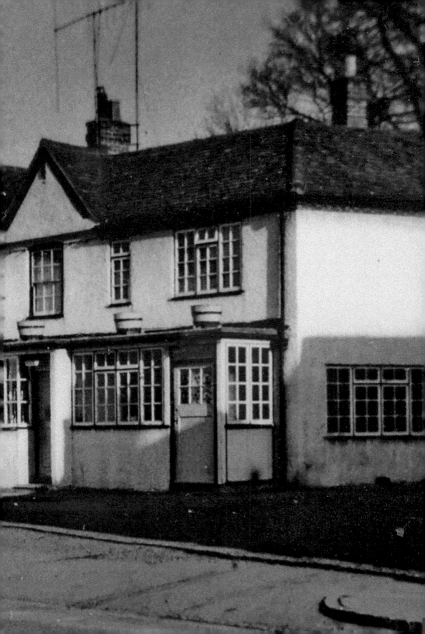

6. WHITE HILL COTTAGES

Back on the old road, going up White Hill, there has been more demolition, with council houses on one side and luxury flats on the other. Here, in this early 1950s image, we see one of the old cottages, now long gone. Whitehall Row led off this hill. Records show 700 people lived in 158 seventeenth-century cottages in this area. Demolition began in the 1920s, proceeding apace for the 1960s dual carriageway. The Plough Inn on the right was demolished.

These days there is a complex mini roundabout at the top of the hill, dealing with heavy traffic from old Oxford Road, now a dual carriageway, Bicester Road, Buckingham Road and Buckingham Street. The old Royal Bucks Hospital stands on the Buckingham Road side. Legendary nurse Florence Nightingale, from the local aristocratic Verney family, played a key role in the hospital's development.

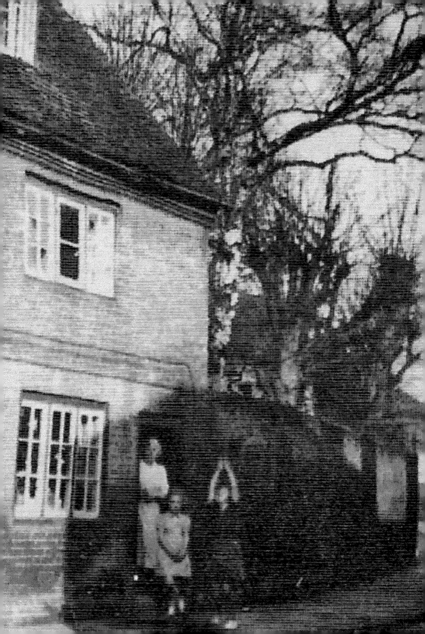

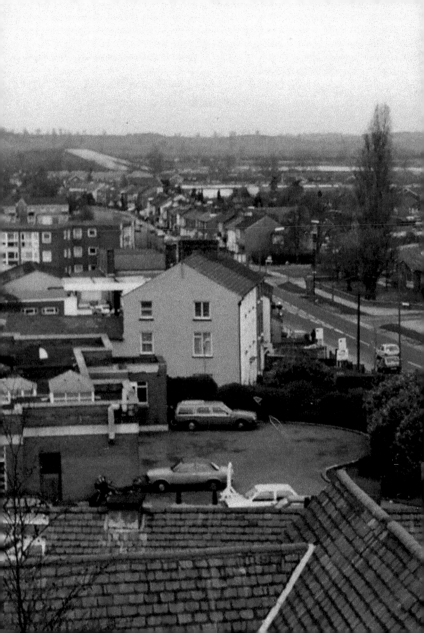

BUCKINGHAM STREET
7. EXPANSION INTO ELMHURST

The view north-east from the Royal Bucks Hospital in March 1988. Aylesbury had three general hospitals in the 1950s, but Stoke Mandeville expanded beyond its paraplegic and plastic surgery wartime specialisms. Tindal, based at the old Manor House opposite the prison, became a mental health centre, as those problems became overwhelming in the modern town. Royal Bucks closed as a specialist maternity centre when all general hospital care was transferred to Stoke Mandeville.

The view here shows some major 1960s expansion into Elmhurst – the ambulance station and garages have long-since gone. On the horizon is the ill-fated Watermead ski slope. It never took off. A bus from the equally defunct Red Rover Bus Company is climbing the Buckingham Road hill into town.

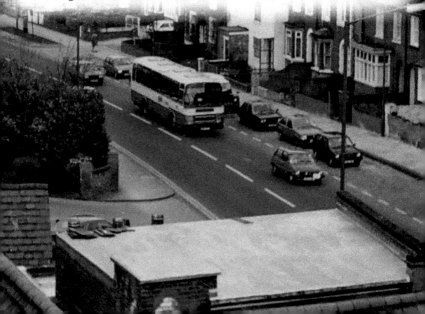

8. AGRO ELECTRICAL SERVICES

Express London–Aylesbury coaches were established by E. M. Cain & Co. with his Red Rover Company in the 1920s. The London Transport Passenger Act of 1933 took over Cain's route for the new Greenline Services, forcing him on to local services.

Here is a Greenline coach parked by Agro Electrical Services, just up from the Aylesbury Motor Company and Royal Bucks roundabout. When the Agro building was being demolished in 1963, the site was used for filming a dummy plane crash episode for TV's *Emergency Ward 10*. The ambulance was filmed coming from the Royal Bucks Hospital.

AGRO ELECTRIC
· COMPANY LTD

RF 234

MLL 771

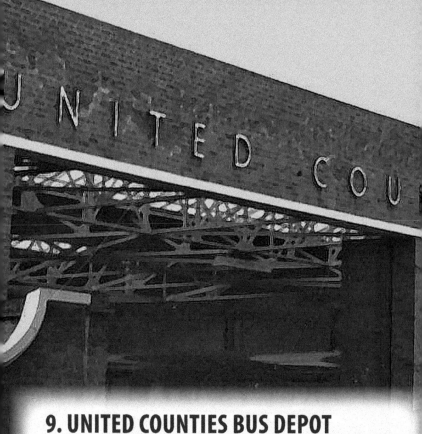

9. UNITED COUNTIES BUS DEPOT

A few yards further up on the same side, in the mid-1960s, we see the old United Counties Bus depot, a subdivision of their Luton Garage. The company was started by a bus crew from Wellingborough in 1921. They illegally used their firm's bus each weekend for pirate services.

By the time someone grassed them up, they had enough money for their own bus. Business flourished so they were taken over by the Thomas Tilling Group, which in turn became part of the National Bus

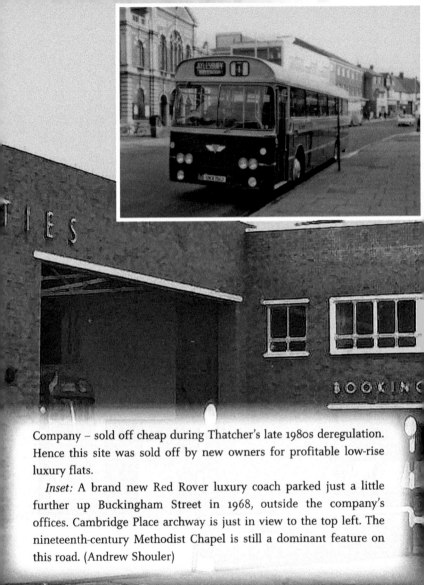

Company – sold off cheap during Thatcher's late 1980s deregulation. Hence this site was sold off by new owners for profitable low-rise luxury flats.

Inset: A brand new Red Rover luxury coach parked just a little further up Buckingham Street in 1968, outside the company's offices. Cambridge Place archway is just in view to the top left. The nineteenth-century Methodist Chapel is still a dominant feature on this road. (Andrew Shouler)

10. CHAMBERLAIN'S

Crossing the road, and toward the end of Buckingham Street, we come to the site of Chamberlain's vehicle bodybuilding workshop. Aylesbury once had its own car building company, Cubitt's, and a history of engineering originally serving agricultural needs. The site was redeveloped as a supermarket in the 1980s. Just a little further along the road is where Bakers Cycles used to be.

Inset: Sadly Baker's toy and cycle shop is long gone – with the new millennium so much is different. The old world atmosphere, aroma and good service was there until the end. It was a model railway and model aircraft builder's heaven.

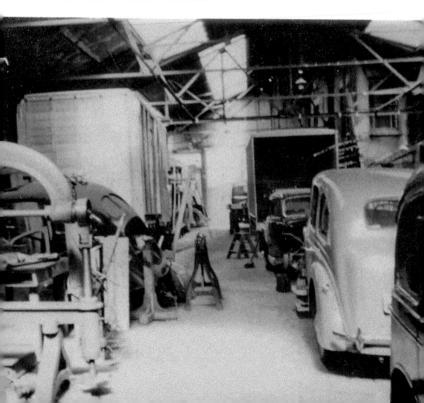

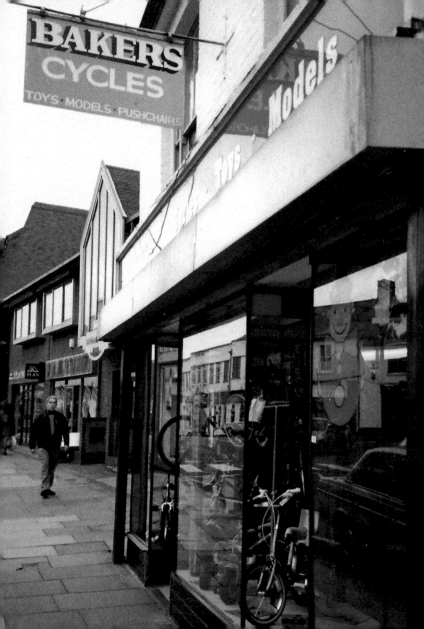

11. WARE'S SLAUGHTERHOUSE

This rickety old building was Ware's slaughterhouse, pictured in the 1960s. It stood almost opposite Baker's. The RTR van belonged to Radio Television rentals because this was an age when televisions were still very expensive to buy and there were only three channels. The Eagle pub is on the left, while Ivatt's local family-run shoe shop is on the right. (John Robinson)

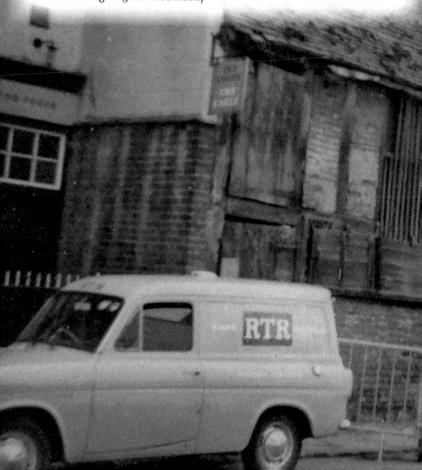

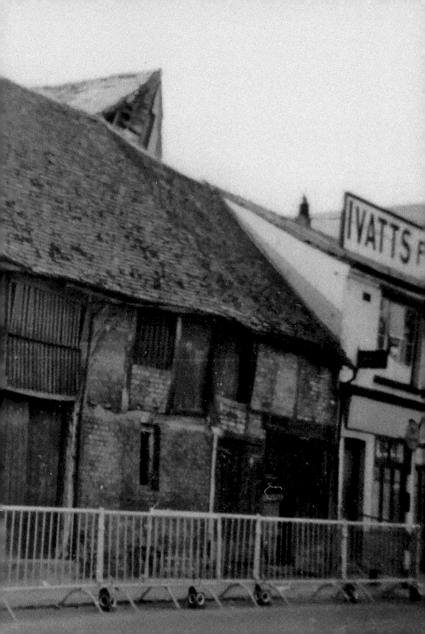

CAMBRIDGE STREET
12. CAMBRIDGE STREET JUNCTION

The best way to view this junction now is to cross the street, walk past Sainsbury's, turn under the Cambridge Place archway, and turn right into Exchange Street (home to the now disused 1960s automated telephone exchange). Looking ahead on what is now the inner ring road dual carriageway, the only landmark left is Domino's on the left corner, formerly the Oddfellows Arms. The American van was one of many leftover army vehicles. An advertisement on the wall is for Herbert Lom's 1950s film *Dual Alibi* at the Granada cinema, which closed to become a bingo hall in 1972.

Top right inset: Evidence of Domino's former life as a pub is still on the wall of this outbuilding, proclaiming the name of the long-gone Oddfellows Arms pub owner, Aylesbury Brewery Company. Behind this wall stands the now almost deserted 1960s Aylesbury Telephone Exchange.'

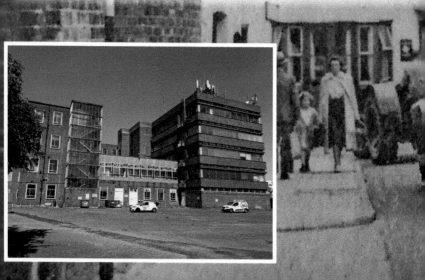

Bottom left inset: Opened in the name of the GPO, this is the deserted BT site of the former revolutionary automatic telephone exchange. Before that 1960s innovation calls were handled by an army of telephonists. The exchange gave the name to the dual carriageway – Exchange Street.

13. ODEON

Turning right at the end of Exchange Street leads into Cambridge Street. The Odeon cinema, pictured here just before closure in 2010, opened in 1936 when Hollywood was making films to take ordinary people's minds off mass unemployment. For all of its years it still had an uplifting appearance, though now replaced by luxury retirement apartments.

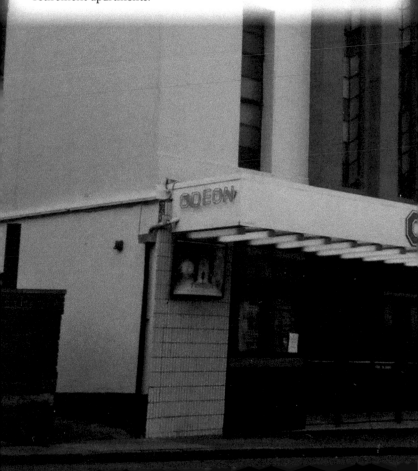

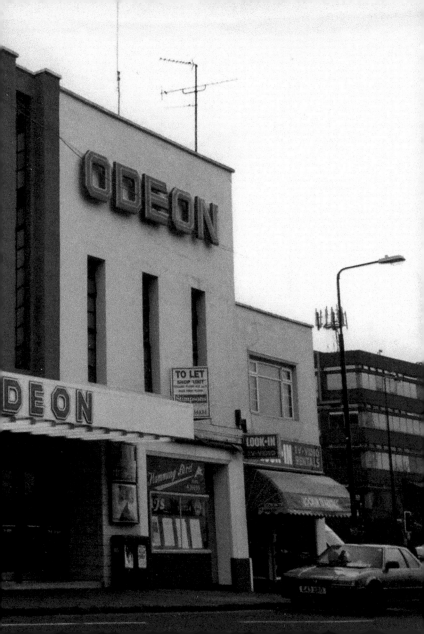

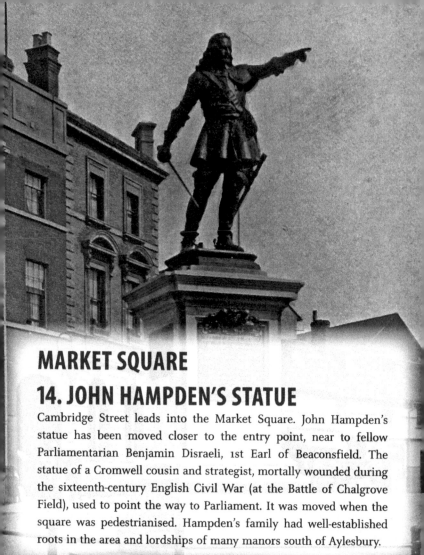

MARKET SQUARE
14. JOHN HAMPDEN'S STATUE

Cambridge Street leads into the Market Square. John Hampden's statue has been moved closer to the entry point, near to fellow Parliamentarian Benjamin Disraeli, 1st Earl of Beaconsfield. The statue of a Cromwell cousin and strategist, mortally wounded during the sixteenth-century English Civil War (at the Battle of Chalgrove Field), used to point the way to Parliament. It was moved when the square was pedestrianised. Hampden's family had well-established roots in the area and lordships of many manors south of Aylesbury.

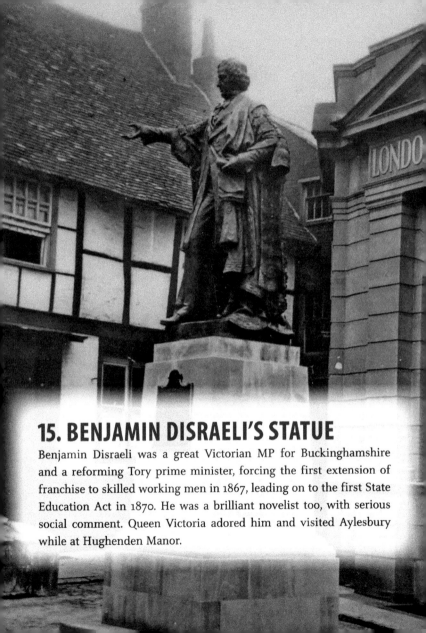

15. BENJAMIN DISRAELI'S STATUE

Benjamin Disraeli was a great Victorian MP for Buckinghamshire and a reforming Tory prime minister, forcing the first extension of franchise to skilled working men in 1867, leading on to the first State Education Act in 1870. He was a brilliant novelist too, with serious social comment. Queen Victoria adored him and visited Aylesbury while at Hughenden Manor.

16. BELL HOTEL AND ENTRANCE TO WALTON STREET

This view, looking south from the statues toward the Bell Hotel and entrance to Walton Street, is now overwhelmed by County Architect Fred Pooley's county offices. The slumbering iron lion, pictured left, was presented by local banker Baron Ferdinand de Rothschild in 1888. The Bell Hotel is the only surviving building. There is a glimpse of The Greyhound pub, demolished during 1960s redevelopment with the licence transferred to another ABC (Aylesbury Brewery Company) tied house on Southcourt estate. The struggle for street lighting began in 1890. Colonel Brown opened a subscription for 'a few miserly oil lamps' (Gibbs). The town was lit and could cook by gas in 1834, and the electric lighting scheme began in 1915.

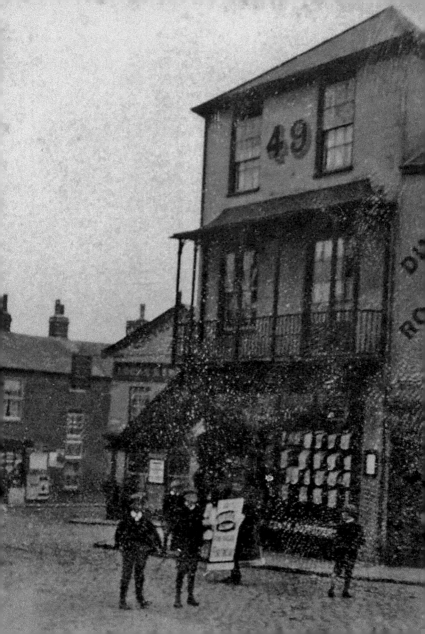

17. FRIAR'S SQUARE SHOPPING CENTRE

Nearly thirty years on, in 1990, state-of-the-art, concrete Friar's Square shopping centre is getting a facelift.

18. COUNTY HALL

Old County Hall was built in 1722–23 on the site of a family home, originally as a courthouse and gaol, with a balcony for public hangings, the last of which was in 1845. It served as the County Assizes until 2016. Public hangings were transferred to the larger, new gaol in Bierton Road. A new county hall was built in Walton Street following the council reforms of 1888, remaining in use opposite the new county office block, built as a mainstay of the 1960s redevelopment. Lord Chesham's statue stands proud in the foreground.

Bottom left inset: Memorial to David Bowie and Aylesbury's great pop performers, sited right, under the archway left of the old courthouse where the Great Train Robbers were convicted.

Top right inset: On 4 October 1664, Nonconformist Winslow minister Benjamin Keach was tried at Aylebury for publishing *The Child's Instructor and Easy Primer*. The judge said: 'You are convicted a seditious book for which the court's judgment is this ... you shall go to court for a fortnight without bail or mainprise and the next Saturday to stand upon the pillory at Aylesbury for the space of two hours...' The judge ordered that the punishment be repeated at Winslow. This image shows punishment in Aylesbury Market Square.

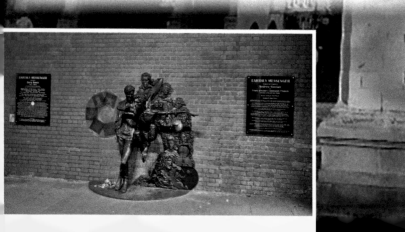

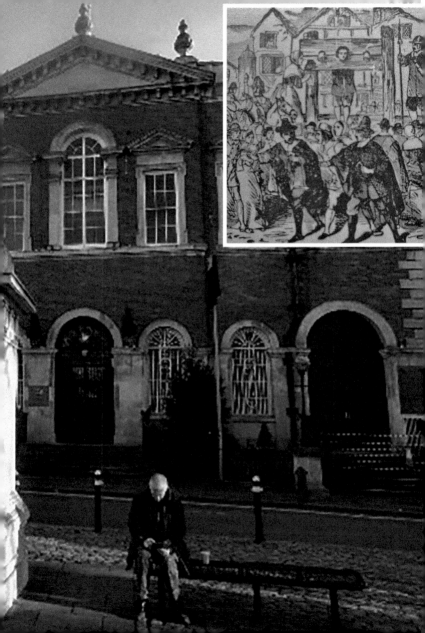

19. GREAT WESTERN STREET

A row of shops in Great Western Street, starting at the Walton Street junction by The Bell. A small branch of the Great Western Railway ran into Aylesbury, hence the name. The newsagents on the corner was very popular with folk dashing to the station on their way to work. (John Huntley)

20. MARKET SQUARE CLOCK TOWER

Still at the bottom of the Market Square, the 1876 clock tower is pre-eminent. This image dates to *c.* 1900. The array of shop names and summer blinds speaks of a humble and rudimentary past that was once thought modern.

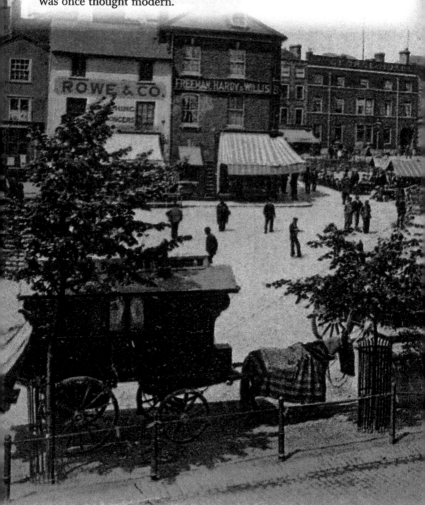

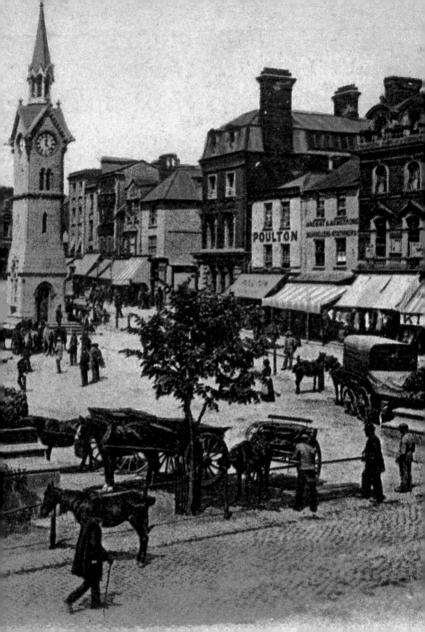

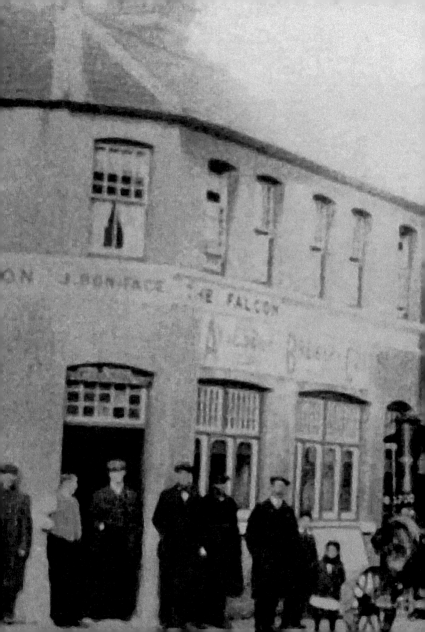

21. THE GREYHOUND AND THE FALCON

Two interesting lost pubs, The Greyhound and The Falcon, in Great Western Street and at the bottom of Great Western Street respectively, before 1960s redevelopment. A Foden steam wagon was then the latest thing in road haulage.

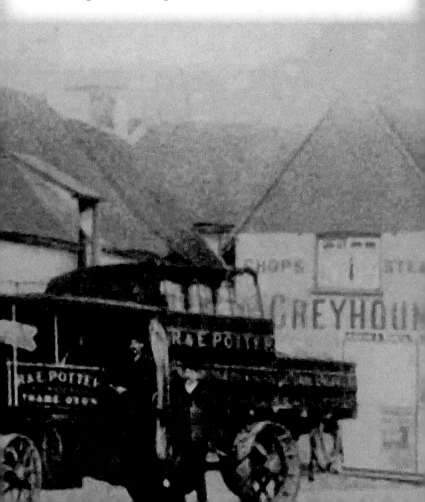

22. DEMOLITION OF OLD AYLESBURY

Early 1960s devastation of old Aylesbury, with little left. Old Silver Lane and Silver Street have no place here, as the 1960s clean-cut concrete shopping centre and council offices are on their way.

Inset: A whole way of life, with basic shops selling boots and other essentials for a hard-working life. This is Market Square, *c.* 1910. It would not be long before these youngsters were called up to defend the empire in the First World War.

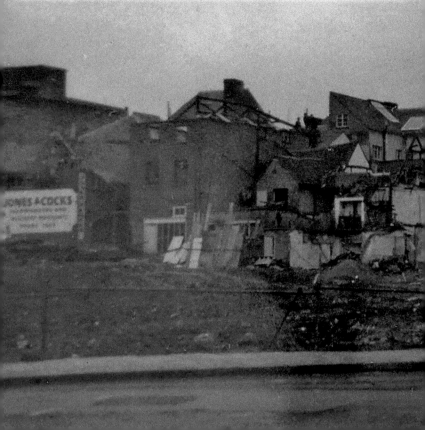

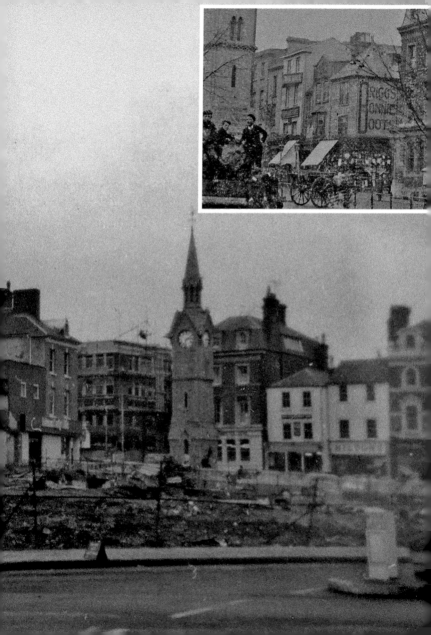

23. WEST SIDE OF MARKET SQUARE

Livestock sales on Market Square in the early 1900s. Sales ceased in 1927, moving to an area under the arches in the Corn Exchange next to County Hall. The alleyway leading to the historic King's Head (a name more popular among Aylesbury Parliamentarians following the beheading of obdurate King Charles I in 1649, because he asserted 'Divine Right' – so betraying his promise to recognise Parliament's sovereignty) is concealed by soon to be demolished seventeenth-century buildings. The entrance to Market Street is by the tobacco advertisement.

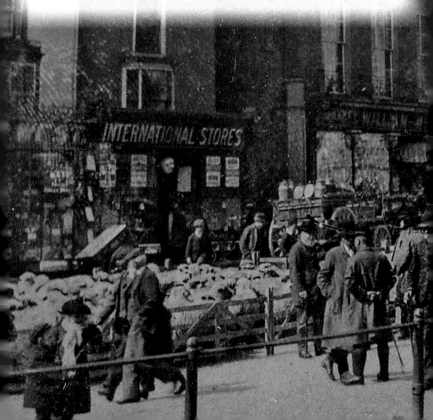

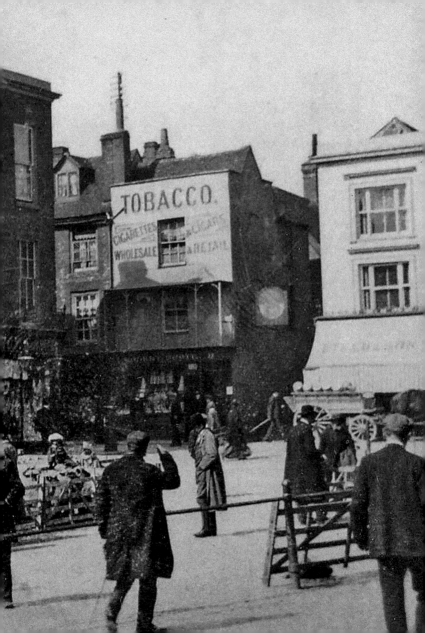

24. JUNCTION OF SILVER STREET AND MARKET SQUARE

Just below the last site we have Silver Street's junction with Market Square. These days the opening is covered by a sheer false brick-faced concrete wall with a commemorative plaque for Elizabeth II's 2002 jubilee visit butting out. Here, back in the early 1960s, the end is nigh, so the shop on the corner advertises a last day sale.

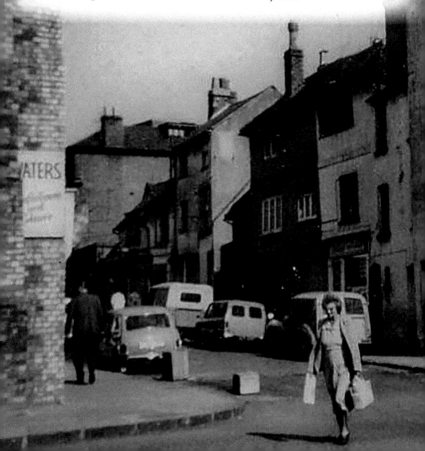

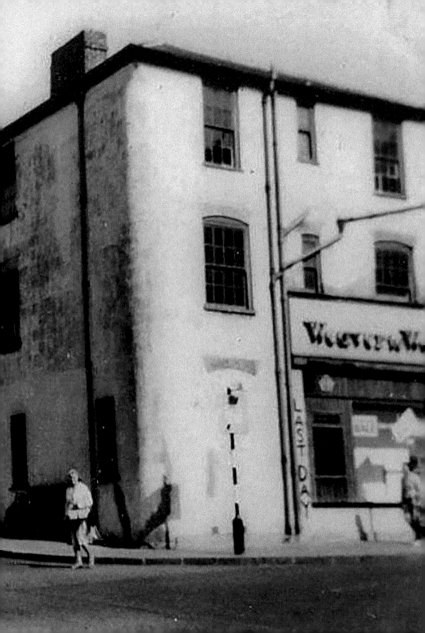

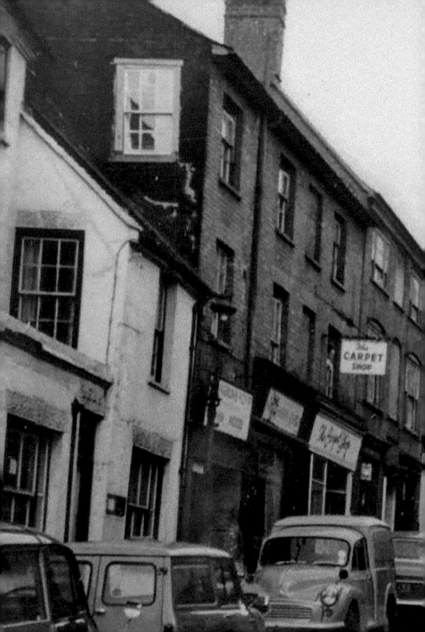

25. SILVER STREET

The last days of Silver Street before demolition. The old ABC Dark Lantern pub is in the middle of the image at the top, the only survivor of the street, but having lost all its character after a fire. Back in the 1960s, it was a popular haunt for local college students and fans of the local Friars pop music club. It was also a target for undercover police looking for illegal drug possession. (D. J. Huntley)

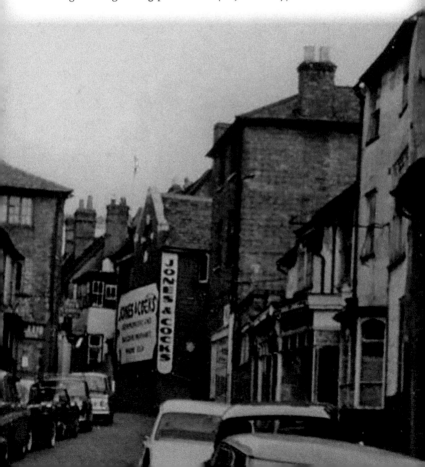

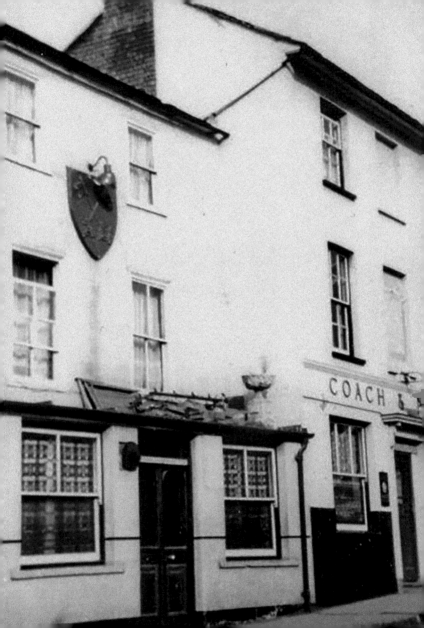

26. COACH & HORSES

This last day's view of the western side of Market Square shows another popular doomed pub that was in the way of the new 1960s Friar's Square shopping centre: the Coach & Horses, which was popular with market traders and shoppers.

27. GEORGE HOTEL

Back to the top of the Square, the George Hotel stands tall in this 1920s view. John Hampden's statue stands next to the war memorial, in its original position. In 1936, a new branch of Burton's tailors opened on the site of the old George. Burton's hit hard times in the 1980s, eventually giving way to Bon Marche, which is now closing down at the time of writing. The premises have foundation stones still in place bearing the names of Raymond Montague and Stanley Howard, who laid them. The massive County Bank stands next door, now owned by Lloyds.

Inset: The King's Head Hotel, pictured in the 1930s, was accessible via an alleyway at the top of Market Square, hidden behind new buildings. This fine Tudor inn is now preserved by the National Trust.

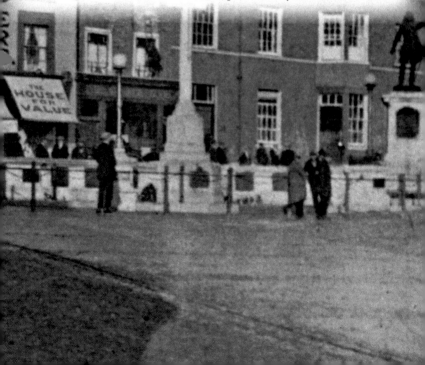

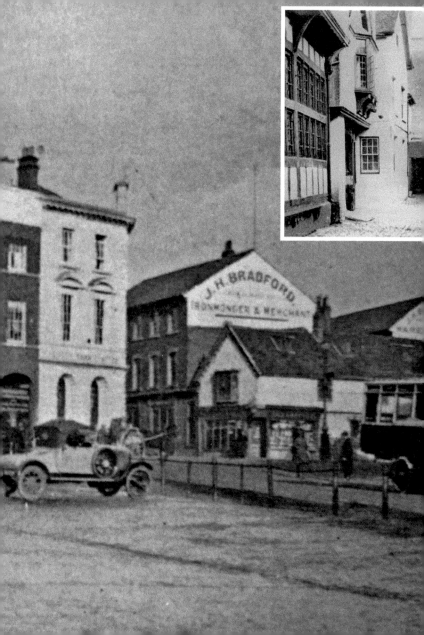

BOURBON STREET
28. THORPE'S GARAGE

Turning left, we face Bourbon Street, where along on the right is the site of what was Thorpe's Garage, here viewed from the corner of the old Slipper Baths. The street got its name from association with members of the fleeing French royal family after the 1789 French Revolution. They occupied the *grande maison* Hartwell House, a few miles south-west of town.

Thorpe's Garage also provided a taxi service, with Ron Rayner appointed manager after wartime army service. Hogeston-based millionaire Armenian Nubar Gulbenkian regularly brought his customised Rolls-Royce for service. The opposite side of the street was demolished for Friar's Square development. (Barbara Thorpe)

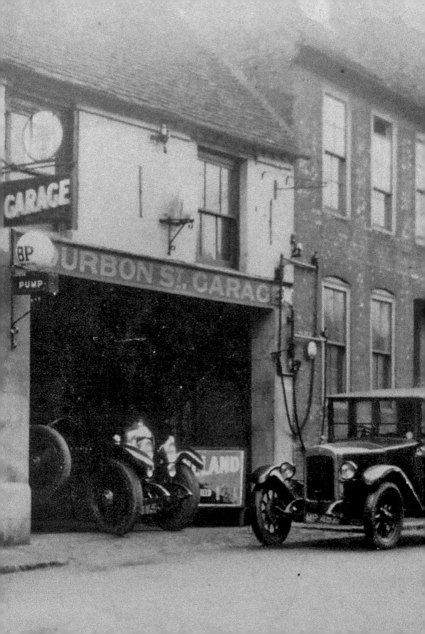

TEMPLE STREET AND SQUARE
29. THE QUEEN'S HEAD

Turning back and left into Temple Street leads on to Temple Square. On the right we pass the Queen's Head' historic pub, pictured here in 1995. The sign bears an image of Queen Elizabeth I. Aylesbury was childhood home to beheaded Queen Anne Boleyn. This is a pretty time warp containing many eighteenth-century buildings. Church Street and St Mary's are off in the distance.

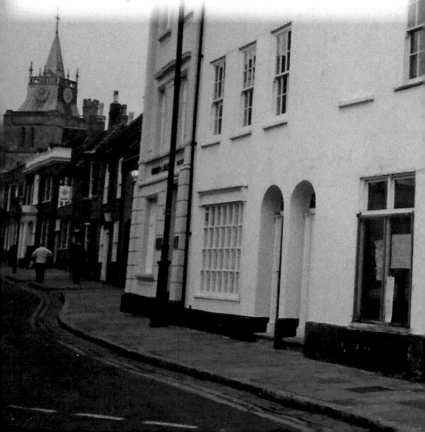

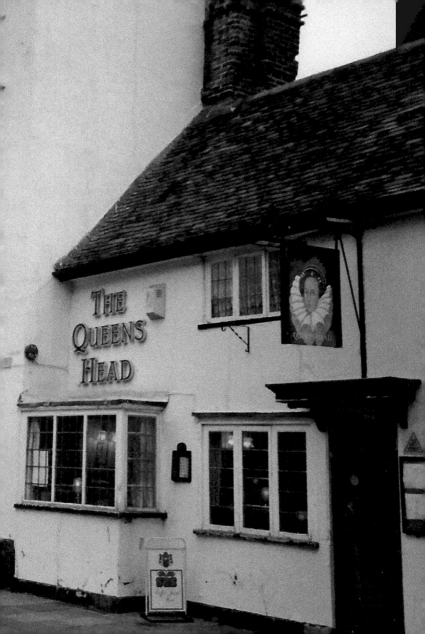

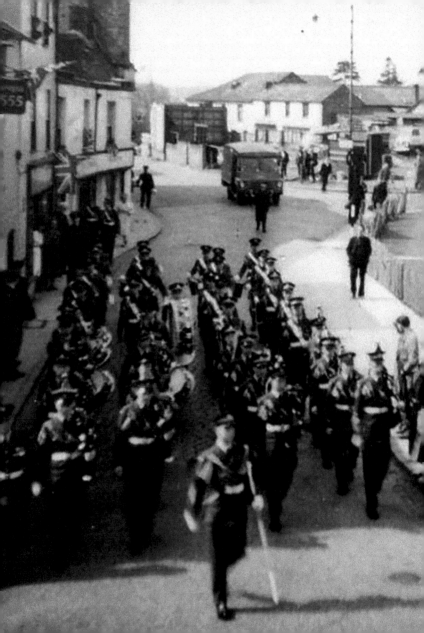

30. RICKFORDS HILL

RAF Halton Camp band marching up the hill into town from Friarage Road, in an area transformed by the massive 1960s redevelopment that obliterated so much of Aylesbury's character.

Sir Frank Whittle, inventor of the jet engine, was among Halton's famous apprentices. Up until the early 1960s RAF personnel were a common sight in Aylesbury's town centre. This faded away with the discharge of the last national servicemen in 1963.

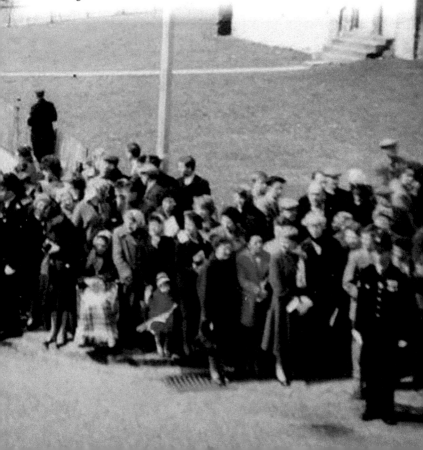

CHURCH STREET
31. CHURCH STREET

Church Street, late 1930s. The building immediately right was the original grammar school, now the County Museum. Early this century Dr Baker, renowned for owning Aylesbury's first motor car, used the house as living quarters and a dispensary. He was inspired by the previous resident, Dr Richard Ceely, a driving force behind the establishing the Royal Bucks Hospital, as well as fighting the 1832 cholera epidemic.

St Mary's Church was restored in 1848–69 and sets the scene. This was the area for almshouses, as seen on the corner, and the workhouse was off to the right along St Mary's Square. Poverty and hardship were normal, in houses cold and damp. Life, for many, without the NHS was 'nasty, brutish and short – infant mortality high'. There was no state education until 1870, and the grammar school was for the better off, even afterwards. Turning left by the almshouses leads into Parson's Fee.

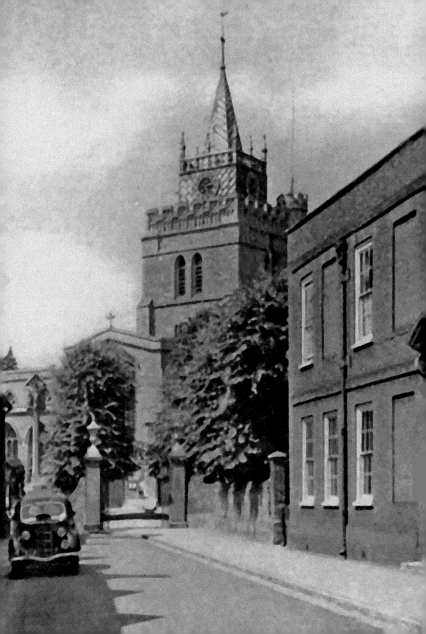

32. JOHN WILKES' PREBENDAL HOUSE

John Wilkes' Prebendal House stands tall, beyond a gateway off Parson's Fee. After losing the Berwick election in 1754 he became High Sheriff, going on to represent Aylesbury in 1757. A famous radical MP and Parlaimentary reformer, he did gaol time while also publishing his newspaper *The North Briton*.

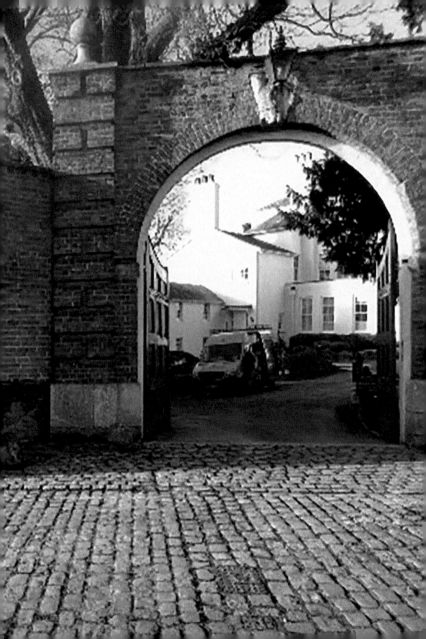

33. FRIARAGE ROAD

Passing on down Castle Street, there is a preserved pebble path overlooking the site of the old Rising Sun pub, another victim of 1960s redevelopment that faced Friarage Road.

Inset: Rising Sun pub, Friarage Road.

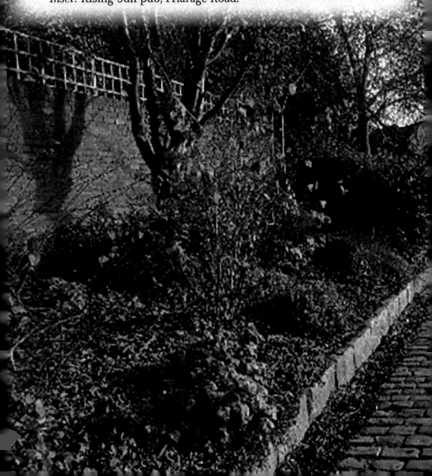

34. BUS STATION

Bus station exit, 1960s. Walking down on to Friarage Road and following left leads past the 1960s concrete bus station under Friar's Square. At the time, the development was home to the largest Woolworths in Europe, with the ground floor now occupied mainly by the County Library in the ailing shopping centre.

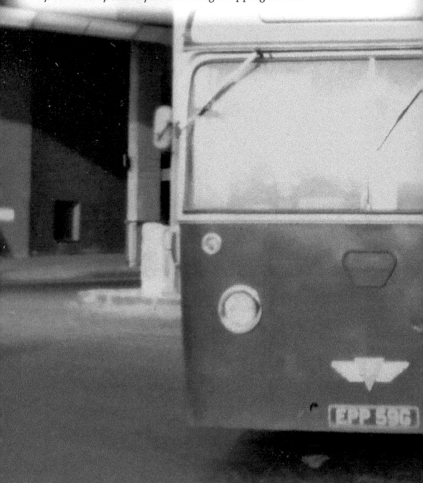

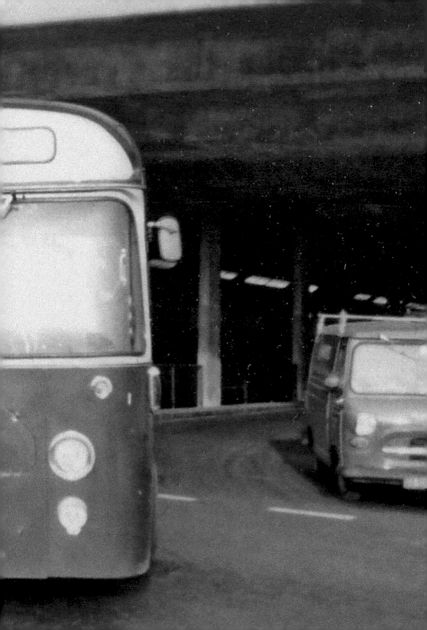

WALTON ROAD
35. AYLESBURY FROM COUNTY OFFICES

Aylesbury viewed north-west from the county offices, 2003, before the major redevelopment removed the Bucks Herald Offices, reduced the boat basin, and added a massive theatre, supermarket and so much more. The Aylesbury branch of the Grand Union Canal opened in 1814 to halve the cost of transporting Midlands coal.

Inset: William Stanley's Walton Cycle and Works, 1910. William ran into patent issues for copying Raleigh parts. During the First World War, the works made shell cases. The premises were demolished for the Walton Street roundabout. (John Harvey Taylor)

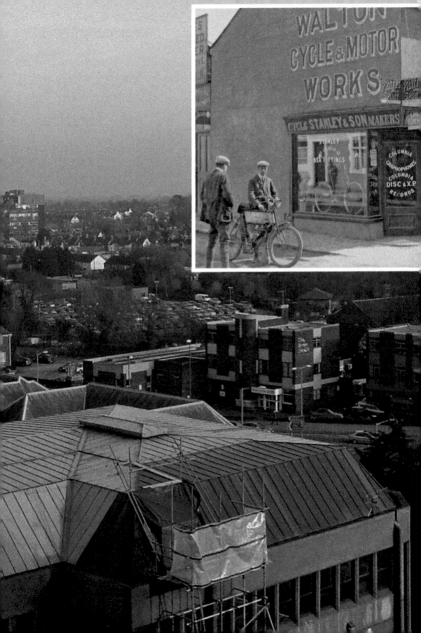

36. WATERSIDE THEATRE, EXCHANGE STREET

The controversial Waterside Theatre, Exchange Street, viewed from Walton Street roundabout, seen here near completion in 2010. It was built partly on the site of the old Bucks Herald offices and boat basin area. Critics thought homelessness and healthcare would have been better recipients of the money spent. However, Aylesbury was trying to update its image and compete with nearby Milton Keynes.

The main image shows the corner of old Bucks County Police HQ made redundant in 1968 when Bucks was one of five forces amalgamated into Thames Valley. Seen here in 2001 (inset), it was used as overspill. It is now a Japanese restaurant. The building adjoins the old county offices constructed in 1928, which are still used, alongside the 1966 tower block.

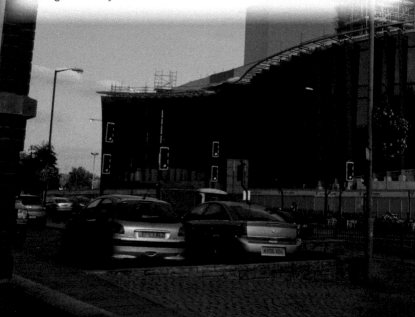

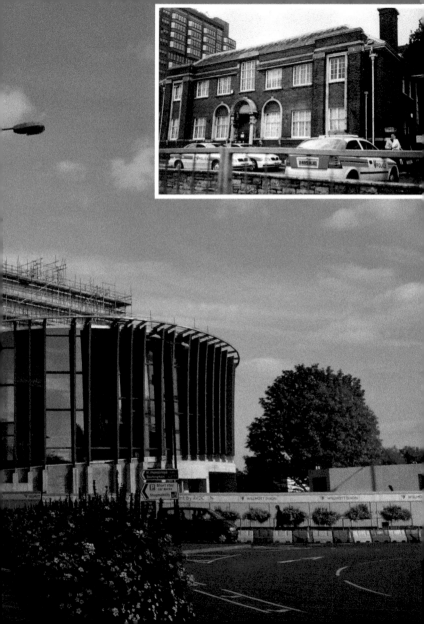

37. OLD CATTLE MARKET AND COUNTY HALL, 1966

Almost opposite the theatre was the old cattle market. The new county offices dwarf the old ones and neighbouring police station.

Builder Marriot's banner hangs high above the top floor. Marriot had a 'quick build' system which was exposed as not quite as concrete as it looked during mid-1980s refurbishment. Key blocks were actually a little bit hollow, as the concrete was not good quality.

No compensation was available because by this time Marriot had been taken over by conglomerate Kier. The discovery gave added meaning to the tower's nickname 'Fred's Folly'. The cattle market in this image was still thriving. The site was excavated in the 1990s to make way for a new Odeon multiplex cinema, the culture asserting a demise of local agriculture for a service future.

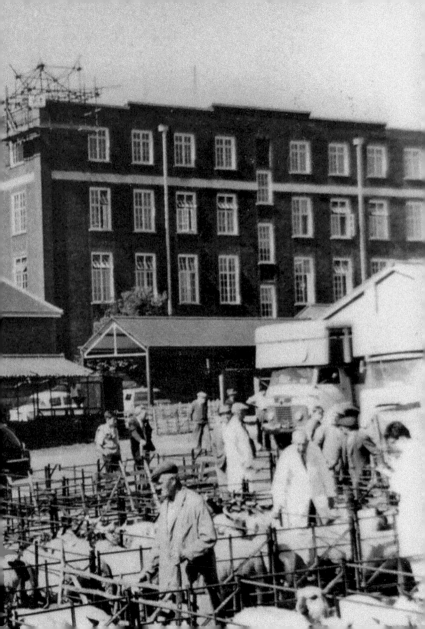

OLD CANAL
38. CANAL BASIN

This image is from 1995, before the major changes to this area. Canals never thrived for business due to the rise of railways, but this branch has thrived for leisure and residential purposes.

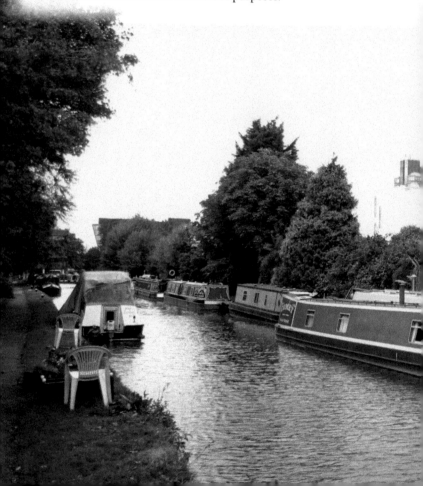

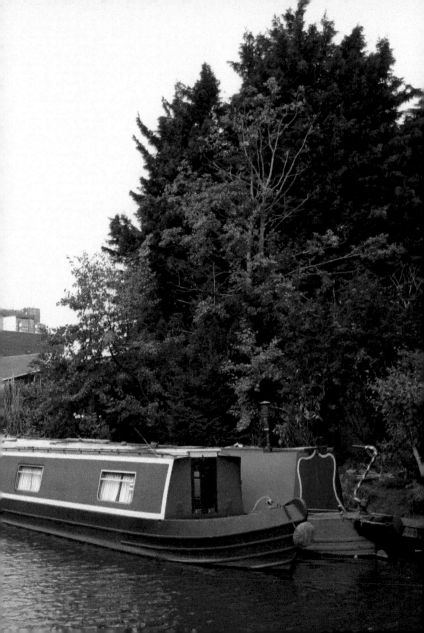

39. HIGH BRIDGE WALK WITH CANAL MURAL

Strolling along the towpath, one arrives at High Bridge, which carries a footpath called High Bridge Walk. A little further on, the path runs under a bridge where several canalside murals have been painted by community members, depicting aspects of town history. Climbing up the steps by this bridge leads out onto the A41, where turning west back into town leads to the High Street.

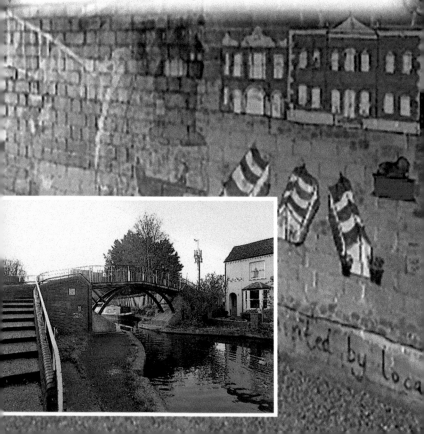

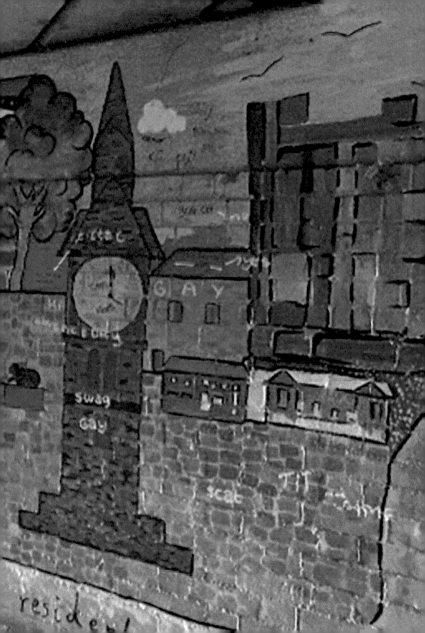

HIGH STREET
40. HIGH STREET AND EXCHANGE STREET, EARLY 1960S

The Chandos Hotel dominates this late 1950s scene at the junction of the High Street and Exchange Street. Named after Buckingham's Lord Chandos, the building was demolished in the early 1970s. Other prominent buildings include the old Granada cinema and some evidence of the, by this time, defunct LNWR station. The gasworks used to be close by, where coal would have been delivered by train.

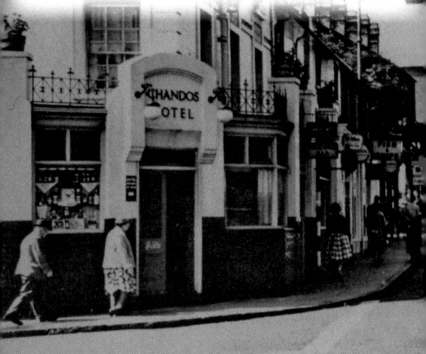

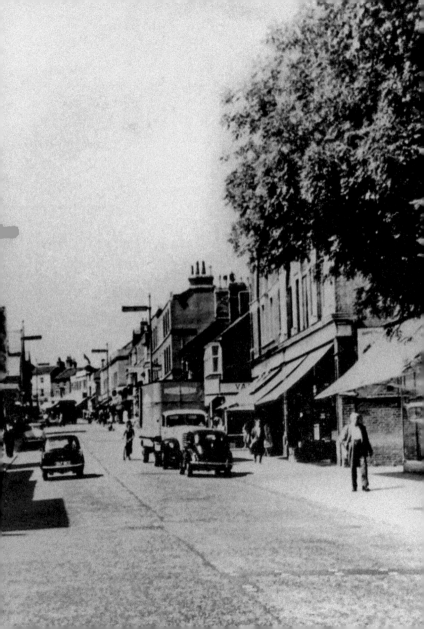

41. OLD RAILWAY STATION, 1950

There is still a small road called Railway Street off the High Street, though a major office block, now empty, dominates the site. The loading bay marks the approximate location of entry to the old scene shown here. In the distance, looking across toward the High Street, we can see the old North and Randall lemonade works, now a block of low-rise flats. The line was opened by the then LNWR in 1839, the station being rebuilt in 1889, with the line connecting to the west coast line at Cheddington. Passenger trains ceased in 1953, and the station was derelict until demolition in 1962. The inset signals (opposite) are models made to mark the historic line's route past the imposing Aylesbury Gaol, where 10,000 people flocked to see the last public hanging, of John Tanwell for the murder of Sarah Hart in 1845. He was the first criminal to have been caught by telegraph, having escaped by train. A young offenders institution now, a lawyer said: 'It is a case of abandon all hope ye who enter here.' The inset below shows the working Cheddington line, viewed from Park Street Bridge, c. 1952. (David Mason)

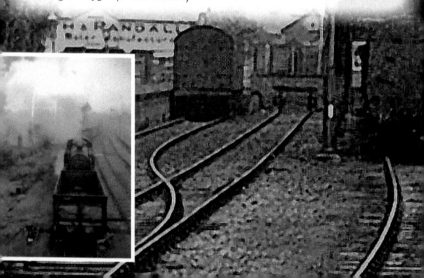

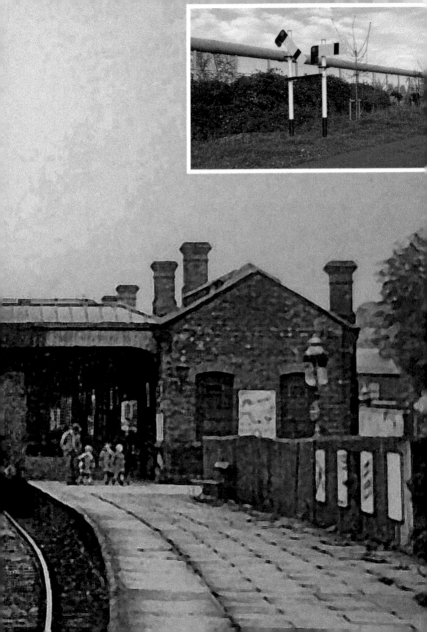

42. GRANADA CINEMA, 1995

Originally the Grand Pavilion Cinema, opening in 1925, Granada Theatres took it over in 1946, closing and turning it into a bingo hall in 1972. It had its moments, as seen in the inset image of the Rolling Stones performing there in 1965.

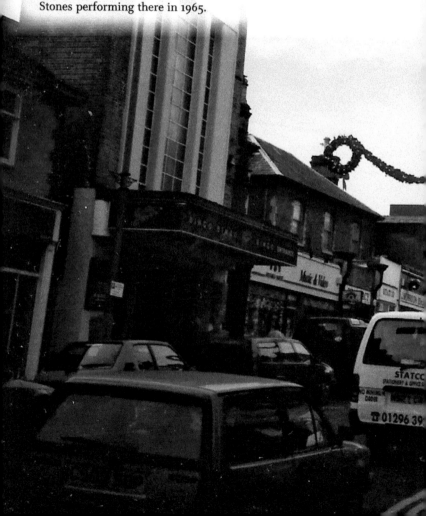

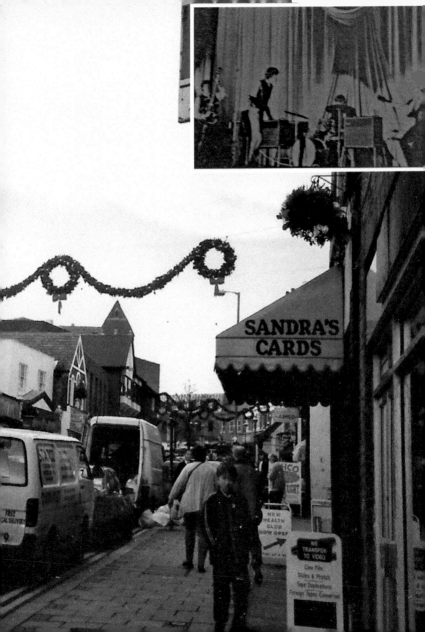

SANDRA'S
CARDS

KINGSBURY
43. ENTRANCE TO KINGSBURY JUNCTION

The busy junction of Buckingham Street, Cambridge Street, High Street and Kingsbury Square, seen here in 1952. Mence Smith was a favourite shop here. Real ground coffee aroma filled the air, and Saturday afternoon was very hectic in this county market town. All the buses, from as far away as High Wycombe and Oxford, used to swing around this bend, as we see here, skilful drivers negotiating the crowded open-air bus park. The inset shows two gleaming AEC double-deckers (Regents) in the fleet of City of Oxford Motor Services. (R. H. G. Simpson)

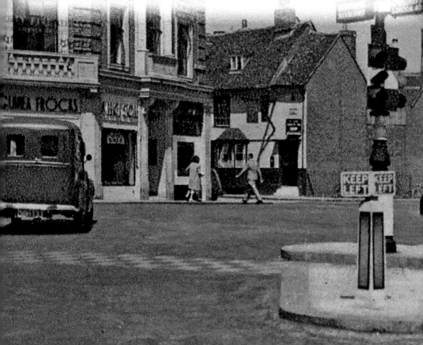

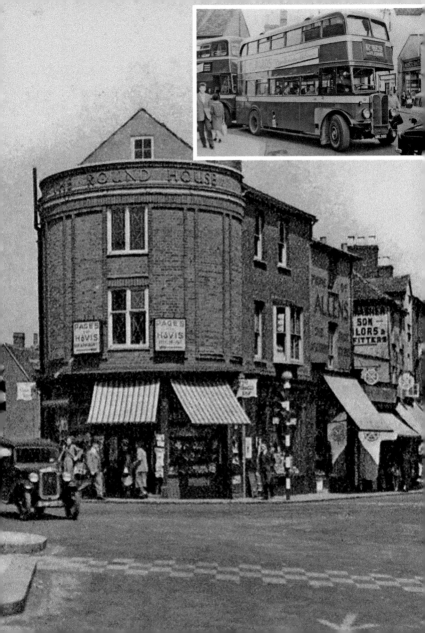

44. KINGSBURY SQUARE

King Henry VIII put Aylesbury on the map after giving it county town status in honour of his new father-in-law, lord of the manor George Boleyn. Kingsbury Square honours the memory of an ill-fated marriage. This early 1930s view includes some interesting state-of-the-art buses and little shops. The Aylesbury Motor Company advertises some of the latest cars. A few years earlier, the building carried a rooftop advert for repairing aeroplanes. By the 1950s, Aylesbury Motor Company moved down near to the Royal Bucks roundabout because bus traffic was so increased. In 1968, the buses moved out to a new purpose-built subterranean bus station, which was dull, smelly and lacked character – that was the 1960s.

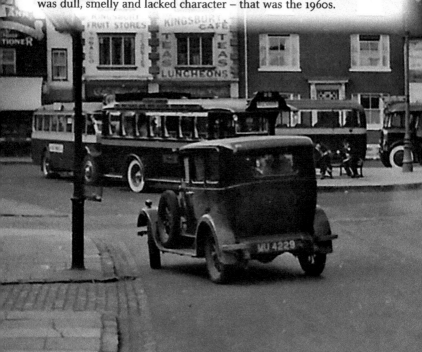

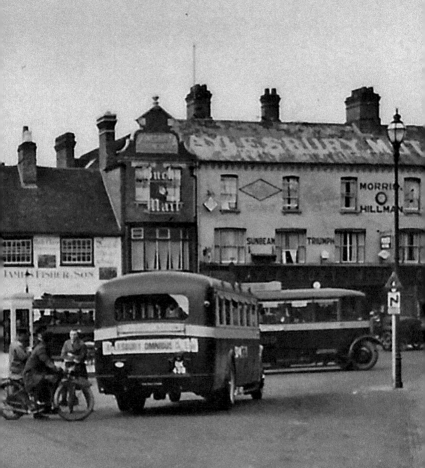

Kingsbury. Aylesbury. No1

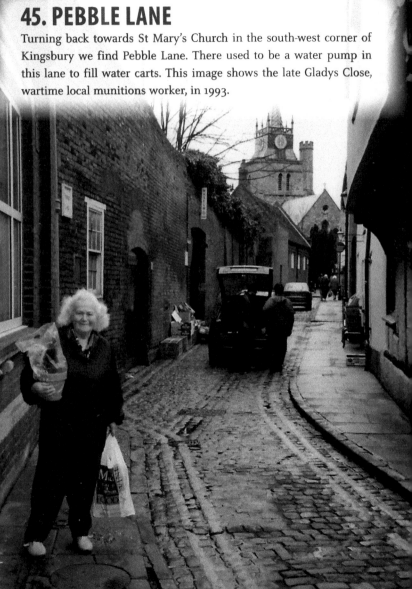

45. PEBBLE LANE

Turning back towards St Mary's Church in the south-west corner of Kingsbury we find Pebble Lane. There used to be a water pump in this lane to fill water carts. This image shows the late Gladys Close, wartime local munitions worker, in 1993.

46. QUEEN'S ROYAL VISIT, 2002

Royalty lifts people's spirits, and Elizabeth II's 2002 jubilee visit was no exception, seen here in Market Square from the Crown Court steps.

ACKNOWLEDGEMENTS

Many thanks to David Mason for sharing his knowledge, experience and images of the Cheddington railway. All other images are either the author's work or collection.

ABOUT THE AUTHOR

Charles Close is the pen name of an experienced local writer and journalist. He has long-standing links to and experience of the local area, and is a graduate of the University of East Anglia.